Oh, to Be a Painter!

David Zwirner Books

ekphrasis

Oh, to Be a Painter!
Virginia Woolf

Introduced and selected by Claudia Tobin

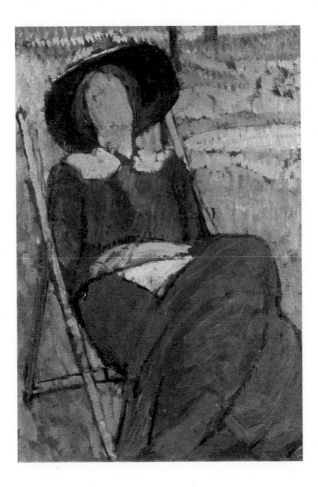

Vanessa Bell, *Virginia Woolf in a Deckchair*, 1912. Oil on board,
14 × 9½ inches | 35.5 × 24 cm

Contents

Introduction

Claudia Tobin

"Painting and writing have much to tell each other," wrote Virginia Woolf in her essay "Walter Sickert: A Conversation" (1934).[1] The conversation between the visual and verbal arts was ongoing, absorbing, and sometimes ambivalent for Woolf throughout her life—debated on the page and in person with her artist and critic friends. But while she is celebrated as one of the most pioneering female writers in English—best known for her intensely visual and formally inventive short stories and novels, such as *To the Lighthouse* (1927) and *Orlando* (1928), and her feminist polemic *A Room of One's Own* (1929)—her texts on visual art remain less discovered. The present volume aims to remedy this by gathering some of her most arresting essays on art, from the early 1920s through the late 1930s, ranging from reviews of contemporary artists and exhibition catalogues to meditations on the role of the artist in society. Read together they illuminate the preoccupations and innovations of Woolf's fiction and nonfiction, and stimulate new hybrids of artist, critic, and writer.

The essays collected here emerged at a time of vibrant experimentation in modern art, in which Woolf's close friends and family—including the critics Roger Fry and Clive Bell, and the painters Duncan Grant and Vanessa Bell—were pioneering figures. We witness Woolf at her most agile and acerbic, a brilliant and perceptive commentator on art even as she dismissed writers as "the worst—the most prejudiced" appraisers of painting.[2] "Let us leave it to the critics to pursue the exciting adventure which waits them in these rooms," Woolf wrote in

her foreword to her sister Vanessa Bell's 1934 exhibition of paintings.[3] She often positioned herself, rather disingenuously, as a reluctant or unqualified judge of art, a writer in a different category from her artist friends. Nevertheless, she had spent the previous two decades honing her critical eye, frequently visiting London's (increasingly international) exhibitions and galleries, recording her responses in her diaries and in correspondence with friends, and publishing articles in some of the leading journals of the day. As early as her review of the London Group painters at the Mansard Gallery in 1924, we see her charting the development of the splinter groups that characterized the British art scene and confidently picking out works worthy of special attention.

Virginia Stephen, as she was known before her marriage to Leonard Woolf, grew up within the milieu of an intellectual and literary Victorian family. Her father, Leslie Stephen, was a biographer and critic, and her mother, Julia Stephen, was much admired by artists associated with the Pre-Raphaelite movement and sat for the painters Edward Burne-Jones and George Frederic Watts. Portraits by Watts lined the walls of the family home in Kensington, alongside photographic portraits of such distinguished men of Victorian Britain as Robert Browning and Charles Darwin—many of them taken by Woolf's aunt Julia Margaret Cameron, one of the most important photographers of the nineteenth century. In her autobiographical essay on her childhood, "A Sketch of the Past" (1939), Woolf described how these "great fig-

ures stood in the background."[4] Later in life, Woolf herself would become an uneasy sitter for portraits by celebrated photographers such as Gisèle Freund. It is not by chance, then, that Woolf's reflections on art wrestle to make sense of portraiture and its parallels with literary biography. Her sense of the evanescent nature of the self, of the play between surface and depth, of inner life and public appearance, and of the difficulty of fixing identity underpins much of her art writing as well as her fiction and criticism.

In 1904, after their parents' deaths, the Stephen sisters—along with their brother Thoby—set up a new matriarchal household at 46 Gordon Square in Bloomsbury (a relatively unfashionable quarter at the time). This marked a definitive shift away from the social and moral codes represented by their parents' generation and toward an aesthetics that signaled their embrace of new freedoms. Bell set the tone with whitewashed walls and vibrant fabrics, which would be joined over the next decade by her increasingly abstract paintings with striking color combinations and geometric forms. Their home at Gordon Square became the backdrop for regular gatherings of artists and intellectuals who would meet for lively debates about art, life, and politics in which no subject, however indelicate, was considered off the table.

Woolf's commitment to writing was matched by Vanessa Bell's dedication to the art of painting. Bell trained at the Royal Academy Schools and was actively involved

in various communities of artists, creating the Friday Club in 1905 as a forum for young artists and cofounding the Omega Workshops cooperative with Fry and Grant in 1913. Throughout their lives, the sisters found mutual inspiration in each other's work, but there was also a strong sense of rivalry, which played out in their correspondence and flickered through Woolf's writing on Bell's art. Woolf acknowledged that the power of Bell's paintings was partly to be found in their resistance to interpretation in language. Her paintings are "as silent as the grave," she wrote in 1930, in the foreword to a catalogue of twenty-seven paintings by Bell.[5] Four years later, when appraising another of Bell's exhibitions, she revealed the potential within her sister's unquiet silence: "Not a word sounds and yet the room is full of conversations." But for Woolf, looking at visual art immediately stirred her storytelling instinct. "What are the people saying who are not sitting on that sofa?" she asked of the paintings. "What tune is the child playing on her silent violin?"[6] As if to evoke in prose something of the elliptical, sometimes disorienting world her sister conjured even as she returned to figurative painting in the 1920s and 1930s, her short foreword of 1934 is constructed from a mosaic of fragments of images and questions, in a syntax spliced by semicolons. It is as though Woolf's own prose must be reconstructed and refined, "purged and purified"[7] (as she wrote in her 1920 essay "Pictures and Portraits"), in order to meet the painter's challenge: to show life "in its essence."[8]

The characterization of painting as still and silent has a long history in the relations between the visual and verbal arts. It was a trope Woolf often deployed not only to acknowledge that there were spaces to which the verbal could not travel but also to stretch the limits of her prose. "There is a zone of silence in the middle of every art," she noted in her essay on Walter Sickert, concluding that "words are an impure medium; better far to have been born into the silent kingdom of paint."[9] Yet this "silent kingdom" is less favorably portrayed in the essay "Pictures," written in 1925, where the painter's world is likened to the muted mystery of the aquarium. Painters "lose their power directly they attempt to speak," Woolf argued.[10] They must communicate through the language of color and form. A similar ambivalence toward art's chilling effect can be traced in her critique of its institutions in her review in the *Athenaeum*, "Pictures and Portraits," where she depicts London's National Gallery and National Portrait Gallery as cut off from humanity in a way that inhibits an engagement with the pictures on display, silent and indifferent as they are to the "rough music" of life on the street outside. Woolf herself famously refused to be painted for the National Portrait Gallery, but visitors to the National Gallery who cast their gaze to the mosaic floor at its entrance will find a portrait of her as Clio, the muse of history, made by her friend the Russian artist Boris Anrep.

In a series of portraits made in the 1910s, during her most experimental and abstract period, Bell offers a

radical vision of Woolf as half absent, her facial features blurred or completely unreadable. Is this Bell's way of silencing her eloquent sister, or perhaps sheltering her from the viewer's intrusive gaze, enabling her inner life to remain private and her identity fluid? As Woolf would write in "Walter Sickert," the "face of a civilized human being is a summing-up, an epitome of a million acts, thoughts, statements and concealments."[11] For many readers and critics of Woolf's most pictorial novel, *To the Lighthouse*, Bell seems a likely model for the character of Lily Briscoe, the painter whose creative struggle we follow as she battles with the notion that "women can't paint, women can't write."[12] When Bell received her artistic training, life drawing was forbidden for women, as Woolf points out in her introduction to Bell's 1930 exhibition catalogue. Balancing creative and domestic life was difficult for women painters, as Bell herself lamented, echoing her sister's words in *A Room of One's Own*: "To paint seriously" and find "room and space to oneself" was something "we females have to struggle for ... all our lives."[13] Woolf often had the impulse to respond to Bell's pictures in language: on seeing her painting *A Conversation*, initially titled *Three Women*, she wrote to her that she was a "short story writer of great wit" and was tempted to "write" the painting in prose.[14]

There was much to stimulate Woolf's literary sense in the realm of modern painting. By the 1920s, she recognized that even literature was "under the dominion of painting": that from Proust's works alone a reader of

the future could find out about painters "of the highest originality and power," such as Matisse, Cézanne, and Derain.[15] Fry had caused a stir with his landmark exhibition of modern French painting in 1910, *Manet and the Post-Impressionists*—the first to introduce these bold, experimental works to a British audience. The exhibition outraged many critics in the British press, but for the artists in Woolf's circle, it represented a "sudden liberation"[16] and radical new purpose for art: seeking "not to imitate life, but to find an equivalent for life," as Fry summed up.[17] A second exhibition followed in 1912 that foregrounded Matisse but also included works by Russian and British artists, including Vanessa Bell and Grant. Fry theorized post-impressionism with Clive Bell (Vanessa's husband), describing how modern French painters, in particular Cézanne, had "recovered ... a whole lost language of form and colour," and, crucially, how this language was universal: anyone could experience "aesthetic emotion" regardless of education.[18]

Woolf questioned the separation between art and life proposed in Fry's early formalist theories, but she praised his democratic vision and admired his critical and communicative powers.[19] Her writing reveals a debt to his introduction of new ways of looking at and understanding different visual experiences, since his scope was wide, chronologically and geographically, including studies of non-Western art from African sculpture to Persian painting.[20] Her opening address for a memorial exhibition of Fry's work in 1935 acclaimed him for

bringing "life and colour" and "racket and din into the quiet galleries of ancient art."[21] She described his monograph on Cézanne of 1927 as "a miracle,"[22] and he in turn offered criticism and praise for her writing. Cézanne is a painter who glows in Woolf's prose: she first recognized the provocative power of his work in 1918, recording in her diary on first viewing his *Still Life with Apples* (1877–1878): "What can six apples *not* be?"[23] Later she declared that his work "seems to challenge us [writers], to press on some nerve, to stimulate, to excite."[24]

The writings collected here are therefore partly the result of a visual attunement born out of close looking at works of art with some of the most radical critics of the day, but also from a life lived in homes that blurred the boundaries between the domestic and the aesthetic. Woolf's role as a collector or patron is rarely discussed, but she supported her artist friends by buying their work and encouraging their mission to bring the innovations of post-impressionism into the fabric of the home. From 1913 to 1919, the Omega Workshops produced decorative arts using bold prints and abstract designs, reinvigorating everyday objects and furnishings. Woolf commissioned ceramics, textiles, and furniture painted by Bell and Grant with vivid colors and patterns, some of which can be seen today at Monk's House (her country cottage in Sussex), alongside pictures by Bell, such as the Cézannian work *Apples* (c. 1918).

Woolf's most sustained exploration of the experience of painting and its power to reconfigure the human

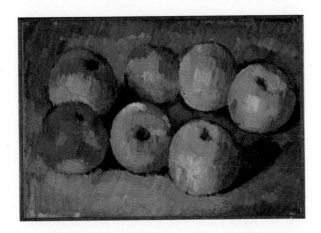

Paul Cézanne, *Still Life with Apples*, 1877–1878. Oil on canvas,
7½ × 10⅝ inches | 19 × 27 cm

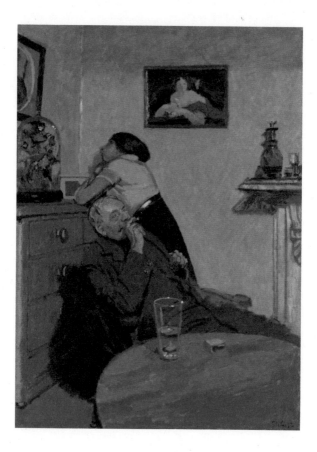

Walter Sickert, *Ennui*, c. 1914. Oil on canvas, 60 × 44¼ inches |
152.4 × 112.4 cm

sensorium can be found in her long essay "Walter Sick-
ert: A Conversation," which is the centerpiece of this vol-
ume. As the subtitle suggests, the text takes the form of
a lively conversation between dinner-party guests and
evokes the kind of scene Woolf would have witnessed on
many evenings among her Bloomsbury friends. Indeed,
she was encouraged to write about Sickert's work after
they were brought together at a dinner party given by
Clive Bell. Sickert, who was of an older generation and a
prominent figure in the Camden Town Group of artists,
supported her efforts, reminding her,"I have always been
a literary painter, thank goodness, like all the decent
painters. Do be the first to say so."[25] Woolf had already
praised Sickert's work in her review of the Mansard Gal-
lery exhibition in 1924 and admired a retrospective of his
work in London almost a decade later, but she was strik-
ing out on a different path from her Bloomsbury friends,
who she felt were rather "down" on his work partly due to
their critique of literary painting and privileging of form
over subject matter.[26] "What is a picture when it has rid
itself of the companionship of language and of music?"
Woolf asked in her essay, which was first published in
the *Yale Review* in September 1934, with the title "A Con-
versation about Art." A month later, a second version was
published by the Hogarth Press, the press Woolf estab-
lished with her husband, Leonard, in 1917. Bell designed
the pamphlet's cover jacket—a simple line drawing on
a green ground of a dinner table set with wine glasses—
which visually introduces the convivial setting. There

were few amendments to the text but perhaps most notable is Woolf's toning down of her conclusion that Sickert was "the best painter now living in England" to the more qualified "probably the best."

The essay is characteristically digressive: it takes off from a question about the invention of picture galleries and leads the reader on a journey through the contemporary debates about pure and literary painting, the nature of the color sense, and the limits of the verbal and visual arts. It is only much later that we encounter Sickert's paintings, and when we do, it is to encounter some of Woolf's finest ekphrastic prose. Paintings such as *Ennui* (c. 1914) and *Nuit d'amour* (c. 1922) inspired extended descriptions blending the seen and the imagined, and exulting in pigment and an appreciation for the eloquence of color and tone in conveying character and mood.[27] Sickert was, Woolf concluded, a "hybrid" artist: in his work the viewer discovers biographies, novels, and stories. As her speakers travel through his scenes of music halls, circuses, and landscapes, what appeals to them is the painter's embrace of humanity in all its facets: his capacity to reveal beauty in the everyday sensory world, one which is both sordid and sublime.

For Woolf, the experience of visual art could involve visceral encounters. In this collection we find the human body being physically altered and expanded: in "Pictures," a group of writers finds themselves intoxicated by the "orgy of blood and nourishment" in a still-life painting;[28] a visitor to Sickert's exhibition experiences color

traveling "spirally" through his body so that he becomes, in Woolf's striking analogy, "all eye," like a South American insect.[29] Here, as in much of her writing, Woolf deployed the language of evolutionary science to suggest something other than an orderly linear progression: in the art gallery we might recover the senses we lost in the "primeval forest."

Her fascination with the development of the visual sense in "Walter Sickert" takes up a trope from her essay on the cinema published in 1926.[30] This youngest art form has been "born fully clothed. It can say everything before it has anything to say." Woolf recognized that the eye, and particularly the "English unaesthetic eye," found itself challenged and disturbed by the new technology of film. She was writing at the inception of film—it was silent and black-and-white in the early 1920s—and it heralded a new and exciting art form yet still without a fully formed language. She was astute about its limitations, first describing it as a "parasite" feeding on the established arts of literature and painting, but over the course of her essay revealing its complexity and potentiality. She recognized that film could offer a radical new nonhuman perspective—something she was experimenting with in her novels, as in the "Time Passes" section of *To the Lighthouse*. If film could not successfully translate the inner experience of a character in a novel—Anna Karenina, for instance, becomes all surface, "all the emphasis is laid … upon her teeth, her pearls, and her velvet"—the filmmaker did have within his grasp the

power to enact the abrupt shifts in time and space that elude the writer. Film might really take a leap forward, Woolf suggested, by making visible a "secret language" of its own. Anticipating the developments of color film, she saw intimations of a new "abstract" art in the chaotic life of the street, where fleeting combinations of color, sound, and movement might be "transfixed" by the new art form.

Woolf was herself deeply interested in the color and "chaos of the streets," and the relationship between art and social and political life is a thread that runs through her art writing. Some critics have seen Bloomsbury as an intellectual clique proclaiming from an ivory tower, but Woolf shared with her close friends a desire to address the role of the artist in society. It was amid the increasing social and political upheaval of the 1930s that she wrote "The Artist and Politics" for the *Daily Worker* newspaper in 1936, at the invitation of the Artists' International Association.[31] Composed two decades after she and many of her friends had made a commitment to pacifism and anti-imperialist activism, and first founded cooperative artist communities, this essay reveals Woolf grappling with the question of where the plastic artist should position himself in the midst of war and crisis. What relation should he have to society? Besieged by the conflicting interests of politicians—"celebrate fascism; celebrate communism"—Woolf argued that the artist must consider whose cause his art serves, and for whom it has meaning. No one is "immune." The artist must take part

in politics and form societies. Woolf asked urgent, difficult questions about art and its survival that resonate in our own times: take note, reader, she seems to say, but also take sustenance from a resolve and belief in art's power to change you.

1 Virginia Woolf, "Walter Sickert: A Conversation" (1934), in this volume, p. 77.
2 Virginia Woolf, "Pictures" (1925), in this volume, p. 37.
3 Virginia Woolf, "Foreword," *Catalogue of Recent Paintings by Vanessa Bell* (1934), in this volume, p. 61.
4 Virginia Woolf, "A Sketch of the Past" (1939), in *Moments of Being*, ed. Jeanne Schulkind (London: Pimlico, 2002), p. 159.
5 Virginia Woolf, "Foreword," *Recent Paintings by Vanessa Bell* (1930), in this volume, p. 56.
6 Woolf, "Foreword" (1934), p. 61.
7 Virginia Woolf, "Pictures and Portraits" (1920), in this volume, p. 28.
8 Woolf, "Foreword" (1934), p. 61.
9 Woolf, "Walter Sickert," p. 70.
10 Woolf, "Pictures," p. 38.
11 Woolf, "Walter Sickert," p. 68.
12 Virginia Woolf, *To the Lighthouse*, ed. David Bradshaw (Oxford: Oxford University Press, 2008), p. 42.
13 Vanessa Bell to Angelica Garnett, November 24, 1941, quoted in Diane Gillespie, *The Sisters' Arts* (New York: Syracuse University Press, 1988), p. 72.
14 Virginia Woolf, May 12, 1928, in *A Change of Perspective: The Letters of Virginia Woolf*, ed. Nigel Nicolson and Joanne Trautmann (London: Hogarth Press, 1977), vol. 3, p. 498.

15 Woolf, "Pictures," p. 35.

16 Vanessa Bell, "Memoirs of Roger Fry," October 1934, typescript, Tate Archive, TGA 20096/1/8-9, p. 9.

17 Roger Fry, "The French Post-Impressionists" (1912), in *Vision and Design* (London: Chatto & Windus, 1920), p. 157.

18 Roger Fry, "Post Impressionism" (1911), in *Roger Fry Reader*, ed. Christopher Reed (London: University of Chicago Press, 1996), p. 108. Clive Bell's influential book *Art* was published in 1914.

19 See Woolf's biography of Fry, published in 1940, for a sense of her appreciation for his work and evolving theories.

20 *Vision and Design*, a collection of Fry's writings, demonstrates his range, including, for instance, the essays "Ancient American Art," "Negro Sculpture," and a review of the "The Munich Exhibition of Mohammedan Art."

21 Virginia Woolf, "Roger Fry," in *The Moment and Other Essays*, ed. Leonard Woolf (London: Hogarth Press, 1947), pp. 83–88.

22 Virginia Woolf, letter to Vanessa Bell, October 8, 1938, in *Congenial Spirits: Selected Letters*, ed. Joanne Trautmann Banks (London: Pimlico, 2003), p. 413.

23 Virginia Woolf, April 18, 1918, in *The Diary of Virginia Woolf*, ed. Anne Olivier Bell, assisted by Andrew McNeillie. 5 vols. (London: Hogarth Press, 1977–1984), vol. 1, p. 140. In her diary recollection, Woolf misremembered or miscounted the number of apples in the painting. She goes on to note the almost hallucinatory effects of this work on its viewers, describing how the apples "positively got redder & rounder & greener."

24 Woolf, "Pictures," p. 38.

25 Walter Sickert, quoted by Virginia Woolf to Quentin Bell, November 26, 1933, in *A Change of Perspective*, vol. 5, p. 253. Woolf attended a retrospective of Sickert's work on view from November to December 1933 at Thomas Agnew & Son, 43 Old Bond Street, London, prompting her to write to the painter to express her admiration.

26 Virginia Woolf to Quentin Bell, November 26, 1933, p. 254.

27 Woolf refers to *Ennui* in "Walter Sickert" as the "picture of the old publican," p. 71.

28 Woolf, "Pictures," p. 39.

29 Woolf, "Walter Sickert," pp. 68, 66.

30 See Virginia Woof, "The Cinema" (1926), in this volume, pp. 42–50.

31 See pp. 82–87 in this volume.

Pictures and Portraits

1920

There are two buildings on the same promontory of pavement, washed by the same incessant tide—the National Gallery and the National Portrait Gallery. In order to enter either it is only necessary to pass through a turnstile, and, on some days of the week, to part with a sixpenny bit. But always, on the paving stone at the doorway, it seems as if the pressure of humanity glued you to its side. As easily might a pilchard leap from the shoal and join the free sport of dolphins as a single individual ascend those steps and enter those doors. The current of the crowd, so swift and deep, the omnibuses swimming bravely on the surface, here a little string of soldiers caught in an eddy, there a hearse, next a pantechnicon van, then the discreet coach of royalty, followed by a black cell upon wheels with a warder at the grating,—all this, floated along in a stream of sound at once continuous and broken up into a kind of rough music, makes it vain to think of pictures. They are too still, too silent.

It would never occur to anyone with a highly developed plastic sense to think of painting as the silent art. Yet that perhaps is at the root of the ordinary English repugnance to pictures. There they hang as if the passage of centuries had left them indifferent. In private stress or public disaster we can wring no message from them. What they see across the room I am not sure: perhaps some gondola in Venice hundreds of years ago. But let who can and will indulge his fancy thus; the little token, the penny bunch of violets brought in from the street, is

silently rejected. Our loves, our desires, the moment's eagerness, the passing problem, receive no sort of sympathy or solution. Under the solemn stare we fade and dwindle and dissolve. Yet it cannot be denied that our resurrection, should it come to pass, is singularly august. We rise, purged and purified; deprived, it is true, of a tongue, but free from the impertinences and solicitations of that too animated and active member. The silence is hollow and vast as that of a cathedral dome. After the first shock and chill those used to deal in words seek out the pictures with the least of language about them—canvases taciturn and congealed like emerald or aquamarine—landscapes hollowed from transparent stone, green hillsides, skies in which the clouds are eternally at rest. Let us wash the roofs of our eyes in colour; let us dive till the deep seas close above our heads. That these sensations are not aesthetic becomes evident soon enough, for, after a prolonged dumb gaze, the very paint on the canvas begins to distil itself into words—sluggish, slow-dropping words that would, if they could, stain the page with colour; not writers' words. But it is not here our business to define what sort of words they are; we are only concerned to prove our unfitness to review the caricatures of Mr. Kapp. His critics are all agreed that he combines the gifts of the artist with those of the caricaturist. We have nothing to say of the artist, but having the National Portrait Gallery in mind, perhaps it may not be presumptuous to approach him from that point of view.

It needs an effort, but scarcely a great one, to enter the National Portrait Gallery. Sometimes indeed an urgent desire to identify one among the dead sends us post haste to its portals. The case we have in mind is that of Mrs. John Stuart Mill. Never was there such a paragon among women. Noble, magnanimous, inspired, thinker, reformer, saint, she possessed every gift and every virtue. One thing alone she lacked, and that, no doubt, the National Portrait Gallery could supply. She had no face. But the National Portrait Gallery, interrogated, wished to be satisfied that the inquirer was dependent upon a soldier; pensions they provided, not portraits; and thus set adrift in Trafalgar Square once more the student might reflect upon the paramount importance of faces. Without a face Mrs. John Stuart Mill was without a soul. Had her husband spared three lines of eulogy to describe her personal appearance we should hold her in memory. Without eyes or hair, cheeks or lips, her stupendous genius, her consummate virtue, availed her nothing. She is a mist, a wraith, a miasma of anonymous merit. The face is the thing. Therefore we turn eagerly, though we have paused too long about it, to see what faces Mr. Kapp provides for the twenty-three gentlemen and the one old lady whom he calls *Personalities*.

There is very little of the anonymous about any of the twenty-four. There is scarcely a personality, from Mr. Bernard Shaw to Mrs. Grundy, whom we have not seen in the flesh. We turn the pages, therefore, to see not what their bodies look like, but whether Mr. Kapp can add

anything to our estimate of their souls. We look, in particular, at the portraits of Lord Morley and of Mr. Bernard Shaw. Years ago Lord Morley shook the hand that writes these words. Whether he was Chief Secretary for Ireland or Prime Minister of England was a matter of complete indifference to a child; a child, presumably, was less than nothing whatever to him. But his manner—cordial, genial, quick as if stepping forward from a genuine impulse of friendliness—has never ceased to shed lustre upon every mention of his name. Where is the handshake in Mr. Kapp's portrait? The lean, smoke-dried pedant's face looks as if scored upon paper by a pen clogged and corroded, as pens are in advertisements, with old ink. It may be so; to Mr. Kapp it must be so; the handshake, perhaps, could only be rendered by a wash of sepia, which would have spoiled the picture as a work of art. Then there is Mr. Bernard Shaw. Gazing from the gallery of some dismal gas-lit hall, one has seen him, often enough, alert, slight, erect, as if combating in his solitary person the forces of inertia and stupidity massed in a sea upon the floor. On a nearer glance, he appeared much of a knight-errant, candid, indeed innocent of aspect; a Don Quixote born in the Northern mists—shrewd, that is to say, rather than romantic. Mr. Kapp has the legendary version—the diabolic. Moustache and eyebrows are twisted into points. The fingers are contorted into stamping hooves. There is no hint of blue in the eye. But again one must remember the limitations of black and white. It is a question of design, texture, handwriting, the

relation of this with that, of art in short, which we pass by with our eyes shut. When we know little or nothing about the subject, and thus have no human or literary susceptibilities to placate, the effect is far more satisfactory. That *The Politician* (Mr. Masterman) has the long body cut into segments and the round face marked with alarming black bars of the Oak Eggar caterpillar, we find it easy and illuminating to believe. There is something sinister about him; he swarms rapidly across roads; he smudges when crushed; he devours leaf after leaf. *The Bishop* (the Bishop of Norwich) is equally symbolical. His is emitting something sonorous through an oblong slit of a mouth; you can almost hear the heavy particle descending through the upper stories of the elongated countenance until it pops with a hollow click out of the orifice. The Duke of Devonshire for all the world resembles a seal sleek from the sea, his mouth pursed to a button signifying a desire for mackerel. But the mackerel he is offered is not fresh, and, tossing himself wearily backwards, he flops with a yawn into the depths. By what sleight of hand Mr. Kapp has conveyed the fact that the golden thread extracted by Sir Henry Wood from the sound of the Queen's Hall Orchestra is really a hair from his soup we do not know. The truth of the suggestion, however unpleasant, is undeniable. But words, words! How inadequate you are! How weary one gets of you! How you will always be saying too much or too little! Oh to be silent! Oh to be a painter! Oh (in short) to be Mr. Kapp!

"It is strange as one enters the Mansard Gallery . . ."

1924

It is strange as one enters the Mansard Gallery today to think that once upon a time the London Group led the van and received into its devoted breast the most pointed arrows of ridicule and criticism. Last week out of a crowd of a hundred private viewers one only, and she elderly and infirm to boot, might be heard to giggle; the rest were able to concentrate their minds not upon their own dignity but upon the pictures—a change marvellous, but welcome. But the Group has not lost its sting in coming of age. It has grown able to practise easily what it once professed self-consciously. The good pictures are as good as, perhaps better than, ever. There is a very fine example of Mr. Sickert; Mr. Thornton proves himself an artist to be reckoned with seriously; Mr. Mathew Smith follows his own bent rather too pugnaciously, for there is danger that his marked personality may stereotype and confine him; Mlle Lessore is exquisitely witty; Mrs. Bell illumines a whole wall, in spite of the drizzle outside, with a flower piece in which every rose seems instinct with brilliant life, yet seized in a moment of intense stillness; in a superb picture of red-hot pokers Mr. Grant makes us hope that he has reconciled the diverse gifts which for the last year or two have been tugging him asunder and puzzling his admirers. But the show is curiously unequal. The goodness of the good accentuates the mediocrity of the bad. And there are one or two problems. What is Mr. Gertler doing? we ask with the curiosity which that remarkable artist always arouses. What mood of dissatisfaction and experiment has him trapped at the moment? A curious stolidity marks his pictures this year. Considered as an end they are disappointing, as a stage in his progress interesting as usual.

Pictures

1925

Probably some professor has written a book on the subject, but it has not come our way. "The Loves of the Arts"—that is more or less the title it would bear, and it would be concerned with the flirtations between music, letters, sculpture, and architecture, and the effects that the arts have had upon each other throughout the ages. Pending his inquiry it would seem on the face of it that literature has always been the most sociable and the most impressionable of them all; that sculpture influenced Greek literature, music Elizabethan, architecture the English of the eighteenth century, and now undoubtedly we are under the dominion of painting. Were all modern paintings to be destroyed, a critic of the twenty-fifth century would be able to deduce from the works of Proust alone the existence of Matisse, Cézanne, Derain, and Picasso; he would be able to say with those books before him that painters of the highest originality and power must be covering canvas after canvas, squeezing tube after tube, in the room next door.

Yet it is extremely difficult to put one's finger on the precise spot where paint makes itself felt in the work of so complete a writer. In the partial and incomplete writers it is much easier to detect. The world is full of cripples at the moment, victims of the art of painting who paint apples, roses, china, pomegranates, tamarinds, and glass jars as well as words can paint them, which is, of course, not very well. We can say for certain that a writer whose writing appeals mainly to the eye is a bad writer; that if in describing, say, a meeting in a garden he

describes roses, lilies, carnations, and shadows on the grass, so that we can see them, but allows to be inferred from them ideas, motives, impulses, and emotions, it is that he is incapable of using his medium for the purposes for which it was created, and is as a writer a man without legs.

But it is impossible to bring that charge against Proust, Hardy, Flaubert, or Conrad. They are using their eyes without in the least impeding their pens, and they are using them as novelists have never used them before. Moors and woods, tropical seas, ships, harbours, streets, drawing-rooms, flowers, clothes, attitudes, effects of light and shade—all this they have given us with an accuracy and a subtlety that make us exclaim that now at last writers have begun to use their eyes. Not indeed that any of these great writers stops for a moment to describe a crystal jar as if it were an end in itself; the jars on their mantelpieces are always seen through the eyes of women in the room. The whole scene, however solidly and pictorially built up, is always dominated by an emotion which has nothing to do with the eye. But it is the eye that has fertilised their thought; it is the eye, in Proust above all, that has come to the help of the other senses, combined with them, and produced effects of extreme beauty, and of a subtlety hitherto unknown. Here is a scene in a theatre, for example. We have to understand the emotions of a young man for a lady in a box below. With an abundance of images and comparisons we are made to appreciate the forms, the colours, the

very fibre and texture of the plush seats and the ladies' dresses and the dullness or glow, sparkle or colour, of the light. At the same time that our senses drink in all this our minds are tunnelling logically and intellectually into the obscurity of the young man's emotions, which as they ramify and modulate and stretch further and further, at last penetrate too far, peter out into such a shred of meaning that we can scarcely follow any more, were it not that suddenly in flash after flash, metaphor after metaphor, the eye lights up that cave of darkness and we are shown the hard tangible material shapes of bodiless thoughts hanging like bats in the primeval darkness where light has never visited them before.

A writer thus has need of a third eye whose function it is to help out the other senses when they flag. But it is extremely doubtful whether he learns anything directly from painting. Indeed it would seem to be true that writers are, of all critics of painting, the worst—the most prejudiced, the most distorted in their judgments; if we accost them in picture galleries, disarm their suspicions and get them to tell us honestly what it is that pleases them in pictures, they will confess that it is not the art of painting in the least. They are not there to understand the problems of the painter's art. They are after something that may be helpful to themselves. It is only thus that they can turn those long galleries from torture chambers of boredom and despair into smiling avenues, pleasant places filled with birds, sanctuaries where silence reigns supreme. Free to go their own way, to pick and

choose at their will, they find modern pictures, they say, very helpful, very stimulating. Cézanne, for example— no painter is more provocative to the literary sense, because his pictures are so audaciously and provocatively content to be paint that the very pigment, they say, seems to challenge us, to press on some nerve, to stimulate, to excite. That picture, for example, they explain (standing before a rocky landscape all cleft in ridges of opal colour as if by a giant's hammer, silent, solid, serene), stirs words in us where we had not thought words to exist; suggests forms where we had never seen anything but thin air. As we gaze, words begin to raise their feeble limbs in the pale border-land of no man's language, to sink down again in despair. We fling them like nets upon a rocky and inhospitable shore; they fade and disappear. It is vain, it is futile; but we can never resist the temptation. The silent painters, Cézanne and Mr. Sickert, make fools of us as often as they choose.

But painters lose their power directly they attempt to speak. They must say what they have to say by shading greens into blues, posing block upon block. They must weave their spells like mackerel behind the glass at the aquarium, mutely, mysteriously. Once let them raise the glass and begin to speak, and the spell is broken. A storytelling picture is as pathetic and ludicrous as a trick played by a dog, and we applaud it only because we know that it is as hard for a painter to tell a story with his brush as it is for a sheep-dog to balance a biscuit on its nose. Dr. Johnson at the Mitre is much better told by Boswell;

in paint, Keats's nightingale is dumb; with half a sheet of notepaper we can tell all the stories of all the pictures in the world.

Nevertheless, they admit, moving round the gallery, even when they do not tempt us to the heroic efforts which have produced so many abortive monsters, pictures are very pleasant things. There is a great deal to be learned from them. That picture of a wet marsh on a blowing day shows us much more clearly than we could see for ourselves the greens and silvers, the sliding streams, the gusty willows shivering in the wind, and sets us trying to find phrases for them, suggests even a figure lying there among the bulrushes, or coming out of the farmyard gate in top-boots and mackintosh. That still-life, they proceed, pointing to a jar of red-hot pokers, is to us what a beefsteak is to an invalid—an orgy of blood and nourishment, so starved we are on our diet of thin black print. We nestle into its colour, feed and fill ourselves with yellow and red and gold till we drop off, nourished and content. Our sense of colour seems miraculously sharpened. We carry those roses and red-hot pokers about with us for days, working them over again in words. From a portrait, too, we get almost always something worth having—somebody's room, nose, or hands, some little effect of character or circumstance, some knick-knack to put in our pockets and take away. But again, the portrait painter must not attempt to speak; he must not say, "This is maternity; that intellect," the utmost he must do is to tap on the wall of the

room, or the glass of the aquarium; he must come very close, but something must always separate us from him.

There are artists, indeed, who are born tappers; no sooner do we see a picture of a dancer tying up her shoe by Degas than we exclaim, "How witty!" exactly as if we had read a speech by Congreve. Degas detaches a scene and comments upon it exactly as a great comic writer detaches and comments, but silently, without for a moment infringing the reticences of paint. We laugh, but not with the muscles that laugh in reading. Mlle Lessore has the same rare and curious power. How witty her circus horses are, or her groups standing with field-glasses gazing, or her fiddlers in the pit of the orchestra! How she quickens our sense of the point and gaiety of life by tapping on the other side of the wall! Matisse taps, Derain taps, Mr. Grant taps; Picasso, Sickert, Mrs. Bell, on the other hand, are all mute as mackerel.

But the writers have said enough. Their consciences are uneasy. No one knows better than they do, they murmur, that this is not the way to look at pictures; that they are irresponsible dragon-flies, mere insects, children wantonly destroying works of art by pulling petal from petal. In short, they had better be off, for here, oaring his way through the waters, mooning, abstract, contemplative, comes a painter, and stuffing their pilferings into their pockets, out they bolt, lest they should be caught at their mischief and made to suffer the most extreme of penalties, the most exquisite of tortures—to be made to look at pictures with a painter.

The Cinema

1926

People say that the savage no longer exists in us, that we are at the fag-end of civilization, that everything has been said already, and that it is too late to be ambitious. But these philosophers have presumably forgotten the movies. They have never seen the savages of the twentieth century watching the pictures. They have never sat themselves in front of the screen and thought how, for all the clothes on their backs and the carpets at their feet, no great distance separates them from those bright-eyed, naked men who knocked two bars of iron together and heard in that clangour a foretaste of the music of Mozart.

The bars in this case, of course, are so highly wrought and so covered over with accretions of alien matter that it is extremely difficult to hear anything distinctly. All is hubble-bubble, swarm, and chaos. We are peering over the edge of a cauldron in which fragments of all shapes and savours seem to simmer; now and again some vast form heaves itself up, and seems about to haul itself out of chaos. Yet, at first sight, the art of the cinema seems simple, even stupid. There is the King shaking hands with a football team; there is Sir Thomas Lipton's yacht; there is Jack Horner winning the Grand National. The eye licks it all up instantaneously, and the brain, agreeably titillated, settles down to watch things happening without bestirring itself to think. For the ordinary eye, the English unaesthetic eye, is a simple mechanism, which takes care that the body does not fall down coalholes, provides the brain with toys and sweetmeats to keep it quiet, and can be trusted to go on behaving like a

competent nursemaid until the brain comes to the conclusion that it is time to wake up. What is its surprise, then, to be roused suddenly in the midst of its agreeable somnolence and asked for help? The eye is in difficulties. The eye wants help. The eye says to the brain, "Something is happening which I do not in the least understand. You are needed." Together they look at the King, the boat, the horse, and the brain sees at once that they have taken on a quality which does not belong to the simple photograph of real life. They have become not more beautiful, in the sense in which pictures are beautiful, but shall we call it (our vocabulary is miserably insufficient) more real, or real with a different reality from that which we perceive in daily life? We behold them as they are when we are not there. We see life as it is when we have no part in it. As we gaze we seem to be removed from the pettiness of actual existence. The horse will not knock us down. The King will not grasp our hands. The wave will not wet our feet. From this point of vantage, as we watch the antics of our kind, we have time to feel pity and amusement, to generalize, to endow one man with the attributes of the race. Watching the boat sail and the wave break, we have time to open our minds wide to beauty and register on top of it the queer sensation—this beauty will continue, and this beauty will flourish whether we behold it or not. Further, all this happened ten years ago, we are told. We are beholding a world which has gone beneath the waves. Brides are emerging from the Abbey—they are now mothers; ush-

ers are ardent—they are now silent; mothers are tearful; guests are joyful; this has been won and that has been lost, and it is over and done with. The war sprung its chasm at the feet of all this innocence and ignorance, but it was thus that we danced and pirouetted, toiled and desired, thus that the sun shone and the clouds scudded up to the very end.

But the picture-makers seem dissatisfied with such obvious sources of interest as the passage of time and the suggestiveness of reality. They despise the flight of gulls, ships on the Thames, the Prince of Wales, the Mile End Road, Piccadilly Circus. They want to be improving, altering, making an art of their own—naturally, for so much seems to be within their scope. So many arts seemed to stand by ready to offer their help. For example, there was literature. All the famous novels of the world, with their well-known characters, and their famous scenes, only asked, it seemed, to be put on the films. What could be easier and simpler? The cinema fell upon its prey with immense rapacity, and to this moment, largely subsists upon the body of its unfortunate victim. But the results are disastrous to both. The alliance is unnatural. Eye and brain are torn asunder ruthlessly as they try vainly to work in couples. The eye says: "Here is Anna Karenina." A voluptuous lady in black velvet wearing pearls comes before us. But the brain says: "That is no more Anna Karenina than it is Queen Victoria." For the brain knows Anna almost entirely by the inside of her mind—her charm, her passion, her despair.

All the emphasis is laid by the cinema upon her teeth, her pearls, and her velvet. Then "Anna falls in love with Vronsky"—that is to say, the lady in black velvet falls into the arms of a gentleman in uniform, and they kiss with enormous succulence, great deliberation, and infinite gesticulation on a sofa in an extremely well-appointed library, while a gardener incidentally mows the lawn. So we lurch and lumber through the most famous novels of the world. So we spell them out in words of one syllable written, too, in the scrawl of an illiterate schoolboy. A kiss is love. A broken cup is jealousy. A grin is happiness. Death is a hearse. None of these things has the least connection with the novel that Tolstoy wrote, and it is only when we give up trying to connect the pictures with the book that we guess from some accidental scene—like the gardener mowing the lawn—what the cinema might do if it were left to its own devices.

But what, then, are its devices? If it ceased to be a parasite, how would it walk erect? At present it is only from hints that one can frame any conjecture. For instance, at a performance of Dr. Caligari the other day, a shadow shaped like a tadpole suddenly appeared at one corner of the screen. It swelled to an immense size, quivered, bulged, and sank back again into nonentity. For a moment it seemed to embody some monstrous, diseased imagination of the lunatic's brain. For a moment it seemed as if thought could be conveyed by shape more effectively than by words. The monstrous, quivering tadpole seemed to be fear itself, and not the state-

ment, "I am afraid." In fact, the shadow was accidental, and the effect unintentional. But if a shadow at a certain moment can suggest so much more than the actual gestures and words of men and women in a state of fear, it seems plain that the cinema has within its grasp innumerable symbols for emotions that have so far failed to find expression. Terror has, besides its ordinary forms, the shape of a tadpole; it burgeons, bulges, quivers, disappears. Anger is not merely rant and rhetoric, red faces and clenched fists. It is perhaps a black line wriggling upon a white sheet. Anna and Vronsky need no longer scowl and grimace. They have at their command—but what? Is there, we ask, some secret language which we feel and see, but never speak, and, if so, could this be made visible to the eye? Is there any characteristic which thought possesses that can be rendered visible without the help of words? It has speed and lowness; dartlike directness and vaporous circumlocution. But it has also, especially in moments of emotion, the picture-making power, the need to lift its burden to another bearer; to let an image run side by side along with it. The likeness of the thought is, for some reason, more beautiful, more comprehensible, more available than the thought itself. As everybody knows, in Shakespeare the most complex ideas form chains of images through which we mount, changing and turning, until we reach the light of day. But, obviously, the images of a poet are not to be cast in bronze, or traced by pencil. They are compact of a thousand suggestions of which the visual is only the most

obvious or the uppermost. Even the simplest image: "My luve's like a red, red rose, that's newly sprung in June," presents us with impressions of moisture and warmth and the glow of crimson and the softness of petals inextricably mixed and strung upon the lilt of a rhythm which is itself the voice of the passion and hesitation of the lover. All this, which is accessible to words, and to words alone, the cinema must avoid.

Yet if so much of our thinking and feeling is connected with seeing, some residue of visual emotion which is of no use either to painter or to poet may still await the cinema. That such symbols will be quite unlike the real objects which we see before us seems highly probable. Something abstract, something which moves with controlled and conscious art, something which calls for the very slightest help from words or music to make itself intelligible, yet justly uses them subserviently—of such movements and abstractions the films may, in time to come, be composed. Then, indeed, when some new symbol for expressing thought is found, the film-maker has enormous riches at his command. The exactitude of reality and its surprising power of suggestion are to be had for the asking. Annas and Vronskys—there they are in the flesh. If into this reality he could breathe emotion, could animate the perfect form with thought, then his booty could be hauled in hand over hand. Then, as smoke pours from Vesuvius, we should be able to see thought in its wildness, in its beauty, in its oddity, pouring from men with their elbows

on a table; from women with their little handbags slipping to the floor. We should see these emotions mingling together and affecting each other.

We should see violent changes of emotion produced by their collision. The most fantastic contrasts could be flashed before us with a speed which the writer can only toil after in vain; the dream architecture of arches and battlements, of cascades falling and fountains rising, which sometimes visits us in sleep or shapes itself in half-darkened rooms, could be realized before our waking eyes. No fantasy could be too far-fetched or insubstantial. The past could be unrolled, distances annihilated, and the gulfs which dislocate novels (when, for instance, Tolstoy has to pass from Levin to Anna, and in so doing jars his story and wrenches and arrests our sympathies) could, by the sameness of the background, by the repetition of some scene, be smoothed away.

How all this is to be attempted, much less achieved, no one at the moment can tell us. We get intimations only in the chaos of the streets, perhaps, when some momentary assembly of colour, sound, movement suggests that here is a scene waiting a new art to be transfixed. And sometimes at the cinema, in the midst of its immense dexterity and enormous technical proficiency, the curtain parts and we behold, far off, some unknown and unexpected beauty. But it is for a moment only. For a strange thing has happened—while all the other arts were born naked, this, the youngest, has been born fully clothed. It can say everything before it has anything to

say. It is as if the savage tribe, instead of finding two bars of iron to play with, had found, scattering the seashore, fiddles, flutes, saxophones, trumpets, grand pianos by Erard and Bechstein, and had begun with incredible energy, but without knowing a note of music, to hammer and thump upon them all at the same time.

Foreword to *Recent Paintings by Vanessa Bell*

1930

That a woman should hold a show of pictures in Bond Street, I said, pausing upon the threshold of Messrs. Cooling's gallery, is not usual, nor, perhaps, altogether to be commended. For it implies, I fancy, some study of the nude, and while for many ages it has been admitted that women are naked and bring nakedness to birth, it was held, until sixty years ago that for a woman to look upon nakedness with the eye of an artist, and not simply with the eye of mother, wife or mistress was corruptive of her innocency and destructive of her domesticity. Hence the extreme activity of women in philanthropy, society, religion and all pursuits requiring clothing.

Hence again the very fact that every Victorian family has in its cupboard the skeleton of an aunt who was driven to convert the native because her father would have died rather than let her look upon a naked man. And so she went to Church; and so she went to China; and so she died unwed; and so there drop out of the cupboard with her bones half a dozen flower pieces done under the shade of a white umbrella in a Surrey garden when Queen Victoria was on the throne.

These reflections are only worth recording because they indicate the vacillations and prevarications (if one is not a painter or a critic of painting) with which one catches at any straw that will put off the evil moment when one must go into the gallery and make up one's mind about pictures. Were it not that Mrs. Bell has a certain reputation and is sometimes the theme of argument at dinner tables, many no doubt would stroll up Bond

Street, past Messrs. Cooling's, thinking about morality or politics, about grandfathers or great aunts, about anything but pictures as is the way of the English.

But Mrs. Bell has a certain reputation it cannot be denied. She is a woman, it is said, yet she has looked on nakedness with a brush in her hand. She is reported (one has read it in the newspapers) to be "the most considerable painter of her own sex now alive." Berthe Morisot, Marie Laurencin, Vanessa Bell—such is the stereotyped phrase which comes to mind when her name is mentioned and makes one's predicament in front of her pictures all the more exacting. For whatever the phrase may mean, it must mean that her pictures stand for something, are something and will be something which we shall disregard at our peril. As soon not go to see them as shut the window when the nightingale is singing.

But once inside and surrounded by canvases, this shillyshallying on the threshold seems superfluous. What is there here to intimidate or perplex? Are we not suffused, lit up, caught in a sunny glow? Does there not radiate from the walls a serene yet temperate warmth, comfortable in the extreme after the rigours of the streets? Are we not surrounded by vineyards and olive trees, by naked girls couched on crimson cushions, by naked boys ankle deep in the pale green sea? Even the puritans of the nineteenth century might grant us a moment's respite from the February murk, a moment's liberty in this serene and ordered world. But it is not the puritans who move us on. It is Mrs. Bell. It is Mrs.

Bell who is determined that we shall not loll about juggling with pretty words or dallying with delicious sensations. There is something uncompromising about her art. Ninety-nine painters had nature given them her susceptibility, her sense of the lustre of grass and flower, of the glow of rock and tree, would have lured us on by one refinement and felicity after another to stay and look for ever. Ninety-nine painters again had they possessed that sense of satire which seems to flash its laughter for a moment at those women in Dieppe in the eighties, would have caricatured and illustrated; would have drawn our attention to the antics of parrots, the pathos of old umbrellas, the archness of ankles, the eccentricities of noses. Something would have been done to gratify the common, innocent and indeed very valuable gift which has produced in England so rich a library of fiction. But look round the room: the approach to these pictures is not by that means. No stories are told; no insinuations are made. The hill side is bare; the group of women is silent; the little boy stands in the sea saying nothing. If portraits there are, they are pictures of flesh which happens from its texture or its modelling to be aesthetically on an equality with the China pot or the chrysanthemum.

Checked at that point in our approach (and the snub is none the less baffling for the beauty with which it is conveyed) one can perhaps draw close from another angle. Let us see if we can come at some idea of Mrs. Bell herself and by thus trespassing, crack the kernel of her

art. Certainly it would hardly be possible to read as many novels as there are pictures here without feeling our way psychologically over the features of the writer; and the method, if illicit, has its value. But here, for a second time, we are rebuffed. One says, Anyhow Mrs. Bell is a woman; and then half way round the room one says, But she may be a man. One says, She is interested in children; one has to add, But she is equally interested in rocks. One asks, Does she show any special knowledge of clothes? One replies, Stark nakedness seems to please her as well. Is she dainty then, or austere? Does she like riding? Is she red haired or brown eyed? Was she ever at a University? Does she prefer herrings or Brussels sprouts? Is she—for our patience is becoming exhausted—not a woman at all, but a mixture of Goddess and peasant, treading the clouds with her feet and with her hands shelling peas? Any writer so ardently questioned would have yielded something to our curiosity. One defies a novelist to keep his life through twenty-seven volumes of fiction safe from our scrutiny. But Mrs. Bell says nothing. Mrs. Bell is as silent as the grave. Her pictures do not betray her. Their reticence is inviolable. That is why they intrigue and draw us on; that is why, if it be true that they yield their full meaning only to those who can tunnel their way behind the canvas into masses and passages and relations and values of which we know nothing—if it be true that she is a painter's painter—still her pictures claim us and make us stop. They give us an emotion. They offer a puzzle.

And the puzzle is that while Mrs. Bell's pictures are immensely expressive, their expressiveness has no truck with words. Her vision excites a strong emotion and yet when we have dramatised it or poetised it or translated it into all the blues and greens, and fines and exquisites and subtles of our vocabulary, the picture itself escapes. It goes on saying something of its own. A good example is to be found in the painting of the Foundling Hospital. Here one says, is the fine old building which has housed a million orphans; here Hogarth painted and kind hearted Thackeray shed a tear, here Dickens, who lived down the street on the left-hand side, must often have paused in his walk to watch the children at play. And it is all gone, all perished. Housebreakers have been at work, speculators have speculated. It is dust and ashes—but what has Mrs. Bell got to say about it? Nothing. There is the picture, serene and sunny, and very still. It represents a fine eighteenth-century house and an equally fine London plane tree. But there are no orphans, no Thackeray, no Dickens, no housebreakers, no speculators, no tears, no sense that this sunny day is perhaps the last. Our emotion has been given the slip.

And yet somehow our emotion has been returned to us. For emotion there is. The room is charged with it. There is emotion in that white urn; in that little girl painting a picture; in the flowers and the bust; in the olive trees; in the provençal vineyard; in the English hills against the sky. Here, we cannot doubt as we look is somebody to whom the visible world has given a shock

of emotion every day of the week. And she transmits it and makes us share it; but it is always by her means, in her language, with her susceptibility, and not ours. That is why she is so tantalising, so original, and so satisfying as a painter. One feels that if a canvas of hers hung on the wall it would never lose its lustre. It would never mix itself up with the loquacities and trivialities of daily life. It would go on saying something of its own imperturbably. And perhaps by degrees—who knows?—one would become an inmate of this strange painters' world, in which mortality does not enter, and psychology is held at bay, and there are no words. But is morality to be found there? That was the very question I was asking myself as I came in.

Foreword to *Catalogue of Recent Paintings
by Vanessa Bell*

1934

As Keats wrote to Haydon, "I have ever been too sensible of the labyrinthian path to eminence in Art ... to think I understood the emphasis of Painting." Let us leave it to the critics to pursue the exciting adventure which waits them in these rooms; to trace the progress of the artist's brush beginning, shall we say, with the chocolate-faced nursemaid and the monolithic figures of 1920; to note the birth of other sensibilities; how blues and oranges trembled into life; how this mass mated itself with that; how the line grew taut or slack; how with an infinitude of varied touches the finished picture came into being. For us the experience has its excitement too. A meaning is given to familiar things that makes them strange. Not a word sounds and yet the room is full of conversations. What are the people saying who are not sitting on that sofa? What tune is the child playing on her silent violin? Nobody moves and yet the room is full of intimate relationships. People's minds have split out of their bodies and become part of their surroundings. Where does the man end and Buddha begin? Character is colour, and colour is china, and china is music. Greens, blues, reds and purples are here seen making love and war and joining in unexpected combinations of exquisite married bliss. A plant bends its leaves in the jar and we feel that we too have visited the depths of the sea.

Cornfields bask in the sun of man's first summer; the haymakers are primeval men. Everywhere life has been rid of its accidents, shown in its essence. The weight of custom has been lifted from the earth. Hampstead is

virginal; Ken Wood ecstatic. The onions and the eggs perform together a solemn music. Flowers toss their heads like proud horses in an Eastern festival. In short, precipitated by the swift strokes of the painter's brush, we have been blown over the boundary to the world where words talk such nonsense that it is best to silence them. And yet it is a world of glowing serenity and sober truth. Compare it, for example, with Piccadilly Circus or St. James's Square.

Walter Sickert: A Conversation

1934

Though talk is a common habit and much enjoyed, those who try to record it are aware that it runs hither and thither, seldom sticks to the point, abounds in exaggeration and inaccuracy, and has frequent stretches of extreme dullness. Thus when seven or eight people dined together the other night the first ten minutes went in saying how very difficult it is to get about London nowadays; was it quicker to walk or to drive; did the new system of coloured lights help or hinder? Just as dinner was announced, somebody asked: "But when were picture galleries invented?," a question naturally arising, for the discussion about the value of coloured lights had led somebody to say that in the eyes of a motorist red is not a colour but simply a danger signal. We shall very soon lose our sense of colour, another added, exaggerating, of course. Colours are used so much as signals now that they will very soon suggest action merely—that is the worst of living in a highly organized community. Other instances of the change wrought upon our senses by modern conditions were then cited; how buildings are changing their character because no one can stand still to look at them; how statues and mosaics removed from their old stations and confined to the insides of churches and private houses lose the qualities proper to them in the open air. This naturally led to the question when picture galleries were first opened, and as no precise answer was forthcoming the speaker went on to sketch a fancy picture of an inventive youth having to wait his turn to cross Ludgate Circus in the reign of Queen Anne. "Look,"

he said to himself, "how the coaches cut across the corners! That poor old boy," he said, "positively had to put his hand to his pig-tail. Nobody any longer stops to look at St. Paul's. Soon all these swinging signboards will be dismantled. Let me take time by the forelock," he said, and, going to his bank, which was near at hand, drew out what remained of his patrimony, and invested it in a neat set of rooms in Bond Street, where he hung the first show of pictures ever to be displayed to the public. Perhaps that is the origin of the House of Agnews; perhaps their gallery stands on the site of the house that was leased, so foreseeingly, by the young man over two hundred years ago. Perhaps, said the others; but nobody troubled to verify the statement, for it was a bitter cold night in December and the soup stood upon the table.

In course of time the talk turned, as talk has a way of turning, back on itself—to colour; how different people see colour differently; how painters are affected by their place of birth, whether in the blue South or the grey North; how colour blazes, unrelated to any object, in the eyes of children; how politicians and business men are blind, days spent in an office leading to atrophy of the eye; and so, by contrast, to those insects, said still to be found in the primeval forests of South America, in whom the eye is so developed that they are all eye, the body a tuft of feather, serving merely to connect the two great chambers of vision. Somebody had met a man whose business it was to explore the wilder parts of the world in search of cactuses, and from him had heard of these

insects who are born with the flowers and die when the flowers fade. A hard-headed man, used to roughing it in all parts of the world, yet there was something moving to him in the sight of these little creatures drinking crimson until they became crimson; then flitting on to violet; then to a vivid green, and becoming for the moment the thing they saw—red, green, blue, whatever the colour of the flower might be. At the first breath of winter, he said, when the flowers died, the life went out of them, and you might mistake them as they lay on the grass for shrivelled air-balls. Were we once insects like that, too, one of the diners asked; all eye? Do we still preserve the capacity for drinking, eating, indeed becoming colour furled up in us, waiting proper conditions to develop? For as the rocks hide fossils, so we hide tigers, baboons, and perhaps insects, under our coats and hats. On first entering a picture gallery, whose stillness, warmth and seclusion from the perils of the street reproduce the conditions of the primeval forest, it often seems as if we reverted to the insect stage of our long life.

"On first entering a picture gallery"—there was silence for a moment. Many pictures were being shown in London at that time. There was the famous Holbein; there were pictures by Picasso and Matisse; young English painters were holding an exhibition in Burlington Gardens, and there was a show of Sickert's pictures at Agnews. When I first went into Sickert's show, said one of the diners, I became completely and solely an insect—all eye. I flew from colour to colour, from red to blue, from

yellow to green. Colours went spirally through my body lighting a flare as if a rocket fell through the night and lit up greens and browns, grass and trees, and there in the grass a white bird. Colour warmed, thrilled, chafed, burnt, soothed, fed and finally exhausted me. For though the life of colour is a glorious life it is a short one. Soon the eye can hold no more; it shuts itself in sleep, and if the man who looks for cactuses had come by he would only have seen a shrivelled air-ball on a red plush chair.

That is an exaggeration, a dramatization, the others said. Nobody, who can walk down Bond Street in the year 1933, without exciting suspicion in the heart of the policeman, can simplify sufficiently to see colour only. One must be a fly in order to die in aromatic pain. And it is many ages now since we lost "the microscopic eye." Ages ago we left the forest and went into the world, and the eye shrivelled and the heart grew, and the liver and the intestines and the tongue and the hands and the feet. Sickert's show proves the truth of that soon enough. Look at his portraits: Charles Bradlaugh at the Bar of the House of Commons; the Right Honourable Winston Churchill, M.P.; Rear-Admiral Lumsden, C.I.E., C.V.O.; and Dr. Cobbledick. These gentlemen are by no means simple flowers. In front of Sickert's portraits of them we are reminded of all that we have done with all our organs since we left the jungle. The face of a civilized human being is a summing-up, an epitome of a million acts, thoughts, statements and concealments. Yes, Sickert is a great biographer, said one of them; when he paints a portrait I

read a life. Think of his picture of the disillusioned lady in full evening-dress sitting on a balcony in Venice. She has seen every sort of sunrise and sunset whether dressed in diamonds or white night-gown; now all is ruin and ship-wreck; and yet the tattered ship in the background still floats. For though Sickert is a realist he is by no means a pessimist ... Laughter drowned the last words. The portrait of the lady on the balcony had suggested nothing of the kind to most of the others. Had she lovers or not—it did not matter; did the ship sail or did it sink—they did not care. And they fetched a book of photographs from Sickert's paintings and began cutting off a hand or a head, and made them connect or separate, not as a hand or a head but as if they had some quite different relationship.

Now they are going into the silent land; soon they will be out of reach of the human voice, two of the diners said, watching them. They are seeing things that we cannot see, just as a dog bristles and whines in a dark lane when nothing is visible to human eyes. They are making passes with their hands, to express what they cannot say; what excites them in those photographs is something so deeply sunk that they cannot put words to it. But we, like most English people, have been trained not to see but to talk. Yet it may be, they went on, that there is a zone of silence in the middle of every art. The artists themselves live in it. Coleridge could not explain *Kubla Khan*—that he left to the critics. And those who are almost on a par with the artists, like our friends who are looking at the pictures, cannot impart what they feel when they

go beyond the outskirts. They can only open and shut their fingers. We must resign ourselves to the fact that we are outsiders, condemned for ever to haunt the borders and margins of this great art. Nevertheless that is a region of very strong sensations. First, on entering a picture gallery, the violent rapture of colour; then, when we have soused our eyes sufficiently in that, there is the complexity and intrigue of character. I repeat, said one of them, that Sickert is among the best of biographers. When he sits a man or woman down in front of him he sees the whole of the life that has been lived to make that face. There it is—stated. None of our biographers make such complete and flawless statements. They are tripped up by those miserable impediments called facts; was he born on such a day; was his mother's name Jane or Mary; then the affair with the barmaid has to be suppressed out of deference to family feeling; and there is always, brooding over him with its dark wings and hooked beak, the Law of Libel. Hence the three or four hundred pages of compromise, evasion, understatement, overstatement, irrelevance and downright falsehood which we call biography. But Sickert takes his brush, squeezes his tube, looks at the face; and then, cloaked in the divine gift of silence, he paints—lies, paltriness, splendour, depravity, endurance, beauty—it is all there and nobody can say, But his mother's name was Jane not Mary. Not in our time will anyone write a life as Sickert paints it. Words are an impure medium; better far to have been born into the silent kingdom of paint.

But to me Sickert always seems more of a novelist than a biographer, said the other. He likes to set his characters in motion, to watch them in action. As I remember it, his show was full of pictures that might be stories, as indeed their names suggest—*Rose et Marie*; *Christine buys a house*; *A difficult moment*. The figures are motionless, of course, but each has been seized in a moment of crisis; it is difficult to look at them and not to invent a plot, to hear what they are saying. You remember the picture of the old publican, with his glass on the table before him and a cigar gone cold at his lips, looking out of his shrewd little pig's eyes at the intolerable wastes of desolation in front of him? A fat woman lounges, her arm on a cheap yellow chest of drawers, behind him. It is all over with them, one feels. The accumulated weariness of innumerable days has discharged its burden on them. They are buried under an avalanche of rubbish. In the street beneath, the trams are squeaking, children are shrieking. Even now somebody is tapping his glass impatiently on the bar counter. She will have to bestir herself; to pull her heavy, indolent body together and go and serve him. The grimness of that situation lies in the fact that there is no crisis; dull minutes are mounting, old matches are accumulating and dirty glasses and dead cigars; still on they must go, up they must get.

And yet it is beautiful, said the other; satisfactory; complete in some way. Perhaps it is the flash of the stuffed birds in the glass case, or the relation of the chest of drawers to the woman's body; anyhow, there is a quality

in that picture which makes me feel that though the publican is done for, and his disillusion complete, still in the other world, of which he is mysteriously a part without knowing it, beauty and order prevail; all is right there— or does that convey nothing to you? Perhaps that is one of the things that is better said with a flick of the fingers, said the other. But let us go on living in the world of words a little longer. Do you remember the picture of the girl sitting on the edge of her bed half naked? Perhaps it is called *Nuit d'Amour*. Anyhow, the night is over. The bed, a cheap iron bed, is tousled and tumbled; she has to face the day, to get her breakfast, to see about the rent. As she sits there with her night-gown slipping from her shoulders, just for a moment the truth of her life comes over her; she sees in a flash the little garden in Wales and the dripping tunnel in the Adelphi where she began, where she will end, her days. So be it, she says, and yawns and shrugs and stretches a hand for her stockings and chemise. Fate has willed it so. Now a novelist who told that story would plunge—how obviously—into the depths of sentimentality. How is he to convey in words the mixture of innocence and sordidity, pity and squalor? Sickert merely takes his brush and paints a tender green light on the faded wallpaper. Light is beautiful falling through green leaves. He has no need of explanation; green is enough. Then again there is the story of Marie and Rose—a grim, a complex, a moving and at the same time a heartening and rousing story. Marie on the chair has been sobbing out some

piteous plaint of vows betrayed and hearts broken to the woman in the crimson petticoat. "Don't be a damned fool, my dear," says Rose, standing before her with her arms akimbo. "I know all about it," she says, standing there in the intimacy of undress, experienced, seasoned, a woman of the world. And Marie looks up at her with all her illusions tearfully exposed and receives the full impact of the other's knowledge, which, however, perhaps because of the glow of the crimson petticoat, does not altogether wither her. There is too much salt and savour in it. She takes heart again. Down she trips past the one-eyed char with a pail, out into the street, a wiser woman than she went in. "So that's what life is," she says, brushing the tear from her eye and hailing the omnibus. There are any number of stories and three-volume novels in Sickert's exhibition.

But to what school of novelists does he belong? He is a realist, of course, nearer to Dickens than to Meredith. He has something in common with Balzac, Gissing and the earlier Arnold Bennett. The life of the lower middle class interests him most—of innkeepers, shopkeepers, music-hall actors and actresses. He seems to care little for the life of the aristocracy whether of birth or of intellect. The reason may be that people who inherit beautiful things sit much more loosely to their possessions than those who have bought them off barrows in the street with money earned by their own hands. There is a gusto in the spending of the poor; they are very close to what they possess. Hence the intimacy that seems to exist in

Sickert's pictures between his people and their rooms. The bed, the chest of drawers, the one picture and the vase on the mantelpiece are all expressive of the owner. Merely by process of use and fitness the cheap furniture has rubbed its varnish off; the grain shows through; it has the expressive quality that expensive furniture always lacks; one must call it beautiful, though outside the room in which it plays its part it would be hideous in the extreme. Diamonds and Sheraton tables never submit to use like that. But whatever Sickert paints has to submit; it has to lose its separateness; it has to compose part of his scene. He chooses, therefore, the casual clothes of daily life that have taken the shape of the body; the felt hat with one feather that a girl has bought with sixpence off a barrow in Berwick Market. He likes bodies that work, hands that work, faces that have been lined and suppled and seamed by work, because, in working, people take unconscious gestures, and their faces have the expressiveness of unconsciousness—a look that the very rich, the very beautiful and the very sophisticated seldom possess. And of course Sickert composes his picture down to the very castors on the chairs and the fire-irons in the grate just as carefully as Turgenev, of whom he sometimes reminds me, composes his scene.

There are many points one could argue in that statement, said the other. But certainly it would seem to be true that Sickert is the novelist of the middle class. At the same time, though he prefers to paint people who use

their hands rather than the leisured, he never sinks below a certain level in the social scale. Like most painters, he has a profound love of the good things of life; well-cooked food, good wine, fine cigars. His world abounds in richness and succulence and humour. He could not draw breath in a starved, a stunted or a puritanical universe. His people are always well fed in body and mind; they excel in mother wit and shrewd knowledge of the world. Some of their sayings are really a little broad; I have always wondered that the censor has let them pass. There is always good company in his pictures. Nothing could be more enjoyable than to sit behind the shop with the French innkeeper—that formidable man in the frock-coat whose name I forget. He would offer us a very fine cigar; uncork a bottle kept for his private use; and Madame would join us from the glass-case where she keeps accounts, and we should sit and talk and sing songs and crack jokes.

Yes, and in the middle of our songs we should look up and see red-gold light dripping down into the green waters of the canal. We should suddenly become aware of a grey church looming over us and one pink cloud riding down the bosom of the west. We should see it suddenly over the shoulders of the innkeeper; and then we should go on talking. That is how Sickert makes us aware of beauty—over the shoulders of the innkeeper; for he is a true poet, of course, one in the long line of English poets, and not the least. Think of his Venice, of his landscapes; or of those pictures of music-halls, of circuses, of street

markets, where the acute drama of human character is cut off; and we no longer make up stories but behold— is it too much to say a vision? But it would be absurd to class Sickert among the visionaries; he is not a rhapsodist; he does not gaze into the sunset; he does not lead us down glorious vistas to blue horizons and remote ecstasies. He is not a Shelley or a Blake. We see his Venice from a little table on the Piazza, just as we are lifting a glass to our lips. Then we go on talking. His paint has a tangible quality; it is made not of air and star-dust but of oil and earth. We long to lay hands on his clouds and his pinnacles; to feel his columns round and his pillars hard beneath our touch. One can almost hear his gold and red dripping with a little splash into the waters of the canal. Moreover, human nature is never exiled from his canvas—there is always a woman with a parasol in the foreground, or a man selling cabbages in the shadow of the arch. Even when he paints a formal eighteenth-century town like Bath, he puts a great cart-wheel in the middle of the road. And those long French streets of pale pink and yellow stucco are all patched and peeled; a child's pink frock hangs out to dry; there are marble-topped tables at the corner. He never goes far from the sound of the human voice, from the mobility and idiosyncrasy of the human figure. As a poet, then, we must liken him to the poets who haunt taverns and sea beaches where the fishermen are tumbling their silver catch into wicker baskets. Crabbe, Wordsworth, Cowper are the names that come to mind, the poets who have

kept close to the earth, to the house, to the sound of the natural human voice.

But here the speakers fell silent. Perhaps they were thinking that there is a vast distance between any poem and any picture; and that to compare them stretches words too far. At last, said one of them, we have reached the edge where painting breaks off and takes her way into the silent land. We shall have to set foot there soon, and all our words will fold their wings and sit huddled like rooks on the tops of the trees in winter. But since we love words let us dally for a little on the verge, said the other. Let us hold painting by the hand a moment longer, for though they must part in the end, painting and writing have much to tell each other; they have much in common. The novelist after all wants to make us see. Gardens, rivers, skies, clouds changing, the colour of a woman's dress, landscapes that bask beneath lovers, twisted woods that people walk in when they quarrel— novels are full of pictures like these. The novelist is always saying to himself how can I bring the sun on to my page? How can I show the night and the moon rising? And he must often think that to describe a scene is the worst way to show it. It must be done with one word, or with one word in skilful contrast with another. For example, there is Shakespeare's "Dear as the ruddy drops that visit this sad heart." Does not "ruddy" shine out partly because "sad" comes after it; does not "sad" convey to us a double sense of the gloom of the mind and the dullness of colour? They both speak at once, striking two notes

to make one chord, stimulating the eye of the mind and of the body. Then again there is Herrick's

"More white than are the whitest creams,
 Or moonlight tinselling the streams."

where the word "tinselling" adds to the simplicity of "white" the glittering, sequined, fluid look of moonlit water. It is a very complex business, the mixing and marrying of words that goes on, probably unconsciously, in the poet's mind to feed the reader's eye. All great writers are great colourists, just as they are musicians into the bargain; they always contrive to make their scenes glow and darken and change to the eye. Each of Shakespeare's plays has its dominant colour. And each writer differs of course as a colourist. Pope has no great range of colour; he is more draughtsman than colourist; clear washes of indigo, discreet blacks and violets best suit his exquisite sharp outlines—save that in the *Elegy to an Unfortunate Lady* there is a mass of funeral black; and the great image of the Eastern King glows, fantastically, if you like, dark crimson. Keats uses colour lavishly, lusciously, like a Venetian. In the *Eve of St. Agnes* he paints for lines at a time, dipping his pen in mounds of pure reds and blues. Tennyson on the other hand is never luscious; he uses the hard brush and the pure bright tints of a miniature painter. *The Princess* is illuminated like a monk's manuscript; there are whole landscapes in the curves of the capital letters. You almost need a magnifying glass to see the minuteness of the detail.

Undoubtedly, they agreed, the arts are closely united. What poet sets pen to paper without first hearing a tune in his head? And the prose-writer, though he makes believe to walk soberly, in obedience to the voice of reason, excites us by perpetual changes of rhythm following the emotions with which he deals. The best critics, Dryden, Lamb, Hazlitt, were acutely aware of the mixture of elements, and wrote of literature with music and painting in their minds. Nowadays we are all so specialized that critics keep their brains fixed to the print, which accounts for the starved condition of criticism in our time, and the attenuated and partial manner in which it deals with its subject.

But we have gossiped long enough, they said; it is time to make an end. The silent land lies before us. We have come within sight of it many times while we were talking; when, for example, we said that Rose's red petticoat satisfied us; when we said that the chest of drawers and the arm convinced us that all was well with the world as a whole. Why did the red petticoat, the yellow chest of drawers, make us feel something that had nothing to do with the story? We could not say; we could not express in words the effect of those combinations of line and colour. And, thinking back over the show, we have to admit that there is a great stretch of silent territory in Sickert's pictures. Consider once more the picture of the music-hall. At first it suggests the husky voice of Marie Lloyd singing a song about the ruins that Cromwell knocked about a bit; then the song dies away, and we see a scooped-out

space filled curiously with the curves of fiddles, bowler hats, and shirt fronts converging into a pattern with a lemon-coloured splash in the centre. It is extraordinarily satisfying. Yet the description is so formal, so superficial, that we can hardly force our lips to frame it; while the emotion is distinct, powerful and satisfactory.

Yes, said the other, it is not a description at all; it leaves out the meaning. But what sort of meaning is that which cannot be expressed in words? What is a picture when it has rid itself of the companionship of language and of music? Let us ask the critics.

But the critics were still talking with their fingers. They were still bristling and shivering like dogs in dark lanes when something passes that we cannot see.

They have gone much farther into the forest than we shall ever go, said one of the talkers, sadly. We only catch a glimpse now and then of what lives there; we try to describe it and we cannot; and then it vanishes, and having seen it and lost it, exhaustion and depression overcome us; we recognize the limitations which Nature has put upon us, and so turn back to the sunny margin where the arts flirt and joke and pay each other compliments.

But do not let us fall into despair, said the other. I once read a letter from Walter Sickert in which he said, "I have always been a literary painter, thank goodness, like all the decent painters." Perhaps then he would not altogether despise us. When we talk of his biographies, his novels, and his poems we may not be so foolish as it seems. Among the many kinds of artists, it may be that

there are some who are hybrid. Some, that is to say, bore deeper and deeper into the stuff of their own art; others are always making raids into the lands of others. Sickert it may be is among the hybrids, the raiders. His name itself suggests that he is of mixed birth. I have read that he is part German, part English, part Scandinavian perhaps; he was born in Munich, was educated at Reading, and lived in France. What more likely than that his mind is also cosmopolitan; that he sings a good song, writes a fine style, and reads enormously in four or five different languages? All this filters down into his brush. That is why he draws so many different people to look at his pictures. From his photograph you might take him for a highly distinguished lawyer with a nautical bent; the sort of man who settles a complicated case at the Law Courts, then changes into an old serge suit, pulls a yachting-cap with a green peak over his eyes and buffets about the North Sea with a volume of Aeschylus in his pocket. In the intervals of hauling up and down the mainsail he wipes the salt from his eyes, whips out a canvas and paints a divinely lovely picture of Dieppe, Harwich, or the cliffs of Dover. That is the sort of man I take Walter Sickert to be. You should call him Richard Sickert, said the other—Richard Sickert, R.A. But since he is probably the best painter now living in England, whether he is called Richard or Walter, whether he has all the letters in the alphabet after his name or none, scarcely matters. Upon that they were all agreed.

The Artist and Politics

1936

I have been asked by the Artist's International Association to explain as shortly as I can why it is that the artist at present is interested, actively and genuinely, in politics. For it seems that there are some people to whom this interest is suspect.

That the writer is interested in politics needs no saying. Every publisher's list, almost every book that is now issued, brings proof of the fact. The historian today is writing not about Greece and Rome in the past, but about Germany and Spain in the present; the biographer is writing lives of Hitler and Mussolini, not of Henry the Eighth and Charles Lamb; the poet introduces communism and fascism into his lyrics; the novelist turns from the private lives of his characters to their social surroundings and their political opinions. Obviously the writer is in such close touch with human life that any agitation in his subject matter must change his angle of vision. Either he focuses his sight upon the immediate problem; or he brings his subject matter into relation with the present; or in some cases, so paralysed is he by the agitations of the moment that he remains silent.

But why should this agitation affect the painter and the sculptor? it may be asked. He is not concerned with the feelings of his model but with its form. The rose and the apple have no political views. Why should he not spend his time contemplating them, as he has always done, in the cold north light that still falls through his studio window?

To answer this question shortly is not easy, for to understand why the artist—the plastic artist—is affected by the state of society, we must try to define the relations of the artist to society, and this is difficult, partly because no such definition has ever been made. But that there is some sort of understanding between them, most people would agree; and in times of peace it may be said roughly to run as follows. The artist on his side held that since the value of his work depended upon freedom of mind, security of person, and immunity from practical affairs— for to mix art with politics, he held, was to adulterate it— he was absolved from political duties; sacrificed many of the privileges that the active citizen enjoyed; and in return created what is called a work of art. Society on its side bound itself to run the state in such a manner that it paid the artist a living wage; asked no active help from him; and considered itself repaid by those works of art which have always formed one of its chief claims to distinction. With many lapses and breaches on both sides, the contract has been kept; society has accepted the artist's work in lieu of other services, and the artist, living for the most part precariously on a pittance, has written or painted without regard for the political agitations of the moment. Thus it would be impossible, when we read Keats, or look at the pictures of Titian and Velasquez, or listen to the music of Mozart or Bach, to say what was the political condition of the age or the country in which these works were created. And if it were otherwise— if the *Ode to a Nightingale* were inspired by hatred of

Germany; if *Bacchus and Ariadne* symbolised the conquest of Abyssinia; if *Figaro* expounded the doctrines of Hitler, we should feel cheated and imposed upon, as if, instead of bread made with flour, we were given bread made with plaster.

But if it is true that some such contract existed between the artist and society, in times of peace, it by no means follows that the artist is independent of society. Materially of course he depends upon it for his bread and butter. Art is the first luxury to be discarded in times of stress; the artist is the first of the workers to suffer. But intellectually also he depends upon society. Society is not only his paymaster but his patron. If the patron becomes too busy or too distracted to exercise his critical faculty, the artist will work in a vacuum and his art will suffer and perhaps perish from lack of understanding. Again, if the patron is neither poor nor indifferent, but dictatorial—if he will only buy pictures that flatter his vanity or serve his politics—then again the artist is impeded and his work becomes worthless. And even if there are some artists who can afford to disregard the patron, either because they have private means or have learnt in the course of time to form their own style and to depend upon tradition, these are for the most part only the older artists whose work is already done. Even they, however, are by no means immune. For though it would be easy to stress the point absurdly, still it is a fact that the practice of art, far from making the artist out of touch with his kind, rather increases his sensibility. It breeds in him a feeling for the

passions and needs of mankind in the mass which the citizen whose duty it is to work for a particular country or for a particular party has no time and perhaps no need to cultivate. Thus even if he be ineffective, he is by no means apathetic. Perhaps indeed he suffers more than the active citizen because he has no obvious duty to discharge.

For such reasons then it is clear that the artist is affected as powerfully as other citizens when society is in chaos, although the disturbance affects him in different ways. His studio now is far from being a cloistered spot where he can contemplate his model or his apple in peace. It is besieged by voices, all disturbing, some for one reason, some for another. First there is the voice which cries: "I cannot protect you; I cannot pay you. I am so tortured and distracted that I can no longer enjoy your works of art." Then there is the voice which asks for help. "Come down from your ivory tower, leave your studio," it cries, "and use your gifts as doctor, as teacher, not as artist." Again there is the voice which warns the artist that unless he can show good cause why art benefits the state he will be made to help it actively—by making aeroplanes, by firing guns. And finally there is the voice which many artists in other countries have already heard and had to obey—the voice which proclaims that the artist is the servant of the politician. "You shall only practise your art," it says, "at our bidding. Paint us pictures, carve us statues that glorify our gospels. Celebrate fascism; celebrate communism. Preach what we bid you preach. On no other terms shall you exist."

With all these voices crying and conflicting in his ears, how can the artist still remain at peace in his studio, contemplating his model or his apple in the cold light that comes through the studio window? He is forced to take part in politics; he must form himself into societies like the Artists' International Association. Two causes of supreme importance to him are in peril. The first is his own survival; the other is the survival of his art.

VIRGINIA WOOLF (1882–1941) is one of the most celebrated modernist authors of twentieth-century England. A prolific writer, Woolf is best-known for her literary fiction, including the novels *Mrs. Dalloway* (1925), *To the Lighthouse* (1927), and *The Waves* (1931), as well as her seminal feminist text *A Room of One's Own* (1929). She is considered to have made major contributions to the stream-of-conscious narrative style, which is characterized by an unsystematic, wandering approach to storytelling. At the turn of the twentieth century, Woolf and her siblings, including her sister, the painter Vanessa Bell, moved to the Bloomsbury district in London, where they held regular meetings with young artists, writers, and intellectuals, such as E. M. Forster, John Maynard Keynes, Lytton Strachey, and Clive Bell. The circle became known as the Bloomsbury Group. In 1917, Woolf and her husband, Leonard, founded their own publishing company, Hogarth Press, which printed some of Woolf's writings. Almost a century after her death, Woolf continues to be a muse for artists across different media. In 2018, a touring exhibition from Tate St Ives explored her writing as an inspiration for more than eighty women artists, from her contemporaries to the present. Her writings continue to stimulate countless painters and sculptors, choreographers, and filmmakers to explore the permeable boundaries between the visual and the verbal.

DR. CLAUDIA TOBIN is a writer, literary critic, curator, and art historian specializing in the relationship between modern and contemporary literature and the visual arts. She is the author of *Modernism and Still Life: Artists, Writers, Dancers* (2020) and coeditor of *Ways of Drawing: Artists' Perspectives and Practices* (2019). She has contributed to two major exhibitions exploring Virginia Woolf's life and art, including *Virginia Woolf: Art, Life and Vision* at the National Portrait Gallery, London (2014), and *Virginia Woolf: An Exhibition Inspired by Her Writings* at Tate St Ives, which traveled to the Pallant House Gallery, Chicester, and The Fitzwilliam Museum, Cambridge (2018). She held a Leverhulme Early Career Fellowship at Cambridge University from 2017 to 2019 and is currently a senior research associate at the Intellectual Forum, Jesus College, Cambridge. She teaches English literature and visual cultures at Cambridge University and contributes to practice-led courses for the Royal Drawing School, London. She has held fellowships in the United Kingdom, the United States, and across Europe, most recently at The Harvard University Center for Italian Renaissance Studies (I Tatti) in Florence.

"Ekphrasis" is traditionally defined as the literary representation of a work of visual art. One of the oldest forms of writing, it originated in ancient Greece, where it referred to the practice and skill of presenting artworks through vivid, highly detailed accounts. Today, "ekphrasis" is more openly interpreted as one art form, whether it be writing, visual art, music, or film, that is used to define and describe another art form, in order to bring to an audience the experiential and visceral impact of the subject.

The *ekphrasis* series from David Zwirner Books is dedicated to publishing rare, out-of-print, and newly commissioned texts as accessible paperback volumes. It is part of David Zwirner Books's ongoing effort to publish new and surprising pieces of writing on visual culture.

OTHER TITLES IN THE *EKPHRASIS* SERIES

We have striven to respect Virginia Woolf's original texts as much as possible by maintaining the original British spelling, syntax, and conventions. In certain rare cases, we have standardized British spellings across texts (though we have retained variant spellings if used consistently) and made slight modifications to punctuation for greater readability and consistency.

PUBLICATION INFORMATION

Unless otherwise indicated below, the texts in this volume have been reproduced from the first published form.

"The Artist and Politics" was first published as "Why Art To-Day Follows Politics" in the *Daily Worker*, New York, December 14, 1936. It was reprinted under the title "The Artist and Politics" in Virginia Woolf, *The Moment and Other Essays*, ed. Leonard Woolf, in 1947 by the Hogarth Press, London. The text reproduced in this volume is taken from the Hogarth Press edition.

"The Cinema" was first published in *The Nation and Athenaeum*, London, July 3, 1926.

"It is strange as one enters the Mansard Gallery ..." is an extract from a review of the *Twenty-First Exhibition of the London Group*, Mansard Gallery, Heal & Son Ltd, 196 Tottenham Court Road, London, 1924, that was first published in the column "From Alpha to Omega" in *The Nation and Athenaeum*, London, October 18, 1924. The text reproduced in this volume is taken from *The Essays of Virginia Woolf, Volume 3: 1919–1924*, ed. Andrew McNeillie, published in 1988 by Harcourt Brace Jovanovich, New York.

"Foreword" was first published in 1930 in the pamphlet *Recent Paintings by Vanessa Bell* that accompanied Bell's solo exhibition organized by the London Artists' Association at 92 New Bond Street, Mayfair, London, 1930.

"Foreword" was first published in 1934 in *Catalogue of Recent Paintings by Vanessa Bell* by Alex. Reid & Lefevre, Ltd. (The Lefevre Galleries), London.

"Pictures," written in 1925, was first published in Virginia Woolf, *The Moment and Other Essays*, ed. Leonard Woolf, in 1947 by the Hogarth Press, London.

"Pictures and Portraits" was first published in *Athenaeum*, London, January 9, 1920, as a review of the exhibition *Personalities: Twenty-Four Drawings* by Edmond X. Kapp at the Little Art Rooms, Duke Street, Adelphi, London, 1919. The text reproduced in this volume is taken from *The Essays of Virginia Woolf, Volume 3: 1919–1924*, ed. Andrew McNeillie, published in 1988 by Harcourt Brace Jovanovich, New York.

"Walter Sickert: A Conversation" was first published as "A Conversation about Art" in the *Yale Review*, New Haven, Connecticut, September 1934. It was published under the title *Walter Sickert: A Conversation* in October 1934 by the Hogarth Press, London. The text reproduced in this volume is taken from the Hogarth Press edition.

Oh, to Be a Painter!
Virginia Woolf

Published by
David Zwirner Books
529 West 20th Street, 2nd Floor
New York, New York 10011
+ 1 212 727 2070
davidzwirnerbooks.com

Managing Director: Doro Globus
Editorial Director: Lucas Zwirner
Sales and Distribution Manager:
Molly Stein

Project Editor: Elizabeth Gordon
Proofreader: Michael Ferut
Design: Michael Dyer / Remake
Production Manager: Jules Thomson
Printing: VeronaLibri, Verona

Typeface: Arnhem
Paper: Holmen Book Cream,
80 gsm

Publication © 2021
David Zwirner Books

Introduction © 2021
Claudia Tobin

Texts by Virginia Woolf © 2021
The Society of Authors/The Estate
of Virginia Woolf. Reprinted
with permission

Photography
p. 5: © Sotheby's/akg-images
p. 17: The Fitzwilliam Museum,
Cambridge. Photo © Reproduced
with the kind permission of
the Provost and Fellows of King's
College, Cambridge
p. 18: Tate, London. Presented
by the Contemporary Art Society,
1924. Photo © Tate

All rights reserved. No part of
this book may be reproduced or
transmitted in any form or by any
means, electronic or mechanical,
including photographing,
recording, or information storage
and retrieval, without prior
permission in writing from the
publisher.

Distributed in the United States
and Canada by
Simon & Schuster, Inc.
1230 Avenue of the Americas
New York, New York 10020
simonandschuster.com

Distributed outside the
United States and Canada by
Thames & Hudson, Ltd.
181A High Holborn
London WC1V 7QX
thamesandhudson.com

ISBN 978-1-64423-058-9

Library of Congress
Control Number: 2021908835